IMAGES
of America

LAUDERDALE
COUNTY

MAP OF LAUDERDALE COUNTY ALABAMA

COMPILED BY
DELOS H. BACON
Manager, Florence Abstract Co.
FLORENCE, ALA.

PUBLISHED BY
THE HUDGINS CO.
Atlanta, Ga.
PRICE $4.00

SCALE IN MILES

1907

SCHOOL DISTRICTS

NO.	NAME	NO.	NAME	NO.	NAME
1	Mitchell's	11	Sego	21	Gravelly Springs
2	Lexington	12	Franks	22	Wrights
3	Greenhill	13	State Line	23	Waterloo
4	Shoal Creek	14	Rogersville	24	Higgins
5	Atlas	15	Cross Roads	25	Haraway
6	Blackburn	16	Center Star	26	Yancey
7	Bethel Grove	17	Harrison	27	Williams
8	Cypress	18	St. Florian	28	Patton
9	Cloverdale	19	Mars Hill	29	Woodland
10	Chapel	20	Oakland	30	Smithsonia

REFERENCE

Boundaries of Voting Precincts
" " School Districts
" " Reserve
Roads
Trace
Rural Free Deliveries
Railroads
Canals
Creeks and Brooks
Post Offices
Villages
Ranges and Township Numbers
School District Numbers
Township Sections
Residences
Churches

Voting Precincts or Beats

NO.	NAME	VOTING PLACE	NO	NAME	VOTING PLACE
	COMMISSIONERS' DISTRICT ONE			DISTRICT THREE	
1	Mitchell's	Anderson	9	St. Florian	St. Florian
2	Rogersville	Rogersville	10	Florence	Florence
3	Lexington	Lexington	11	Rawhide	Cloverdale
4	Cross Roads	Cross roads	12	Oakland	Oakland
	DISTRICT TWO		13	Woodland	Woodland
5	Green Hill	Green Hill		DISTRICT FOUR	
6	Center Star	Center Star	14	Chapel	Chapel
7	Poplar Springs	Poplar Springs	15	Gravelly Sprigs	Gravelly Sprigs
8	Blackburn	Hines	16	Cove Springs	Smithsonia
19	Atlas	Atlas	17	Waterloo	Waterloo
			18	Spains	Spains Bottom

This colorful 1907 representation of Lauderdale County, compiled by the Abstract Company in Florence, offers a wealth of information for historians and family history researchers. In addition to divisions by the county's 18 voting districts, or beats, the map indicates school districts, post offices, communities, churches, and even some residences. (Author's collection.)

ON THE COVER: Bailey Springs resort was a popular 1800s wellness retreat on Shoal Creek, about nine miles north of downtown Florence. Visitors from all over the United States came to "take the waters" from the property's mineral springs. Pictured in this undated photograph are Virginia Ellis, whose family owned and managed the resort for decades; Helen Gordon; and Tommie Kilburn. (Courtesy of University of North Alabama Archives.)

IMAGES
of America

LAUDERDALE
COUNTY

Patricia Bryant Hartley

ARCADIA
PUBLISHING

Published by Arcadia Publishing
Charleston, South Carolina

Printed in the United States of America

Library of Congress Control Number: 2023932345

For all general information, please contact Arcadia Publishing:
Telephone 843-853-2070
Fax 843-853-0044
E-mail sales@arcadiapublishing.com
For customer service and orders:
Toll-Free 1-888-313-2665

Visit us on the Internet at www.arcadiapublishing.com

For my family with love and thanks for their care, patience, and support and in reverent memory of local historian William "Bill" McDonald.

CONTENTS

ACKNOWLEDGMENTS

This book would not have been possible without the generous contributions of images and stories from wonderful folks who share my love and respect for the rich history of Lauderdale County and my dedication to preserving it. Lee Freeman, local history/genealogy librarian at the Florence-Lauderdale Public Library, along with library staff members Colby Dow and Jordan Collier, facilitated several opportunities to gather and scan images, and I treasure their expertise and support.

I am grateful to Arcadia Publishing and editor Caitrin Cunningham for providing me the opportunity to finally meet several of our county's notable historians, including Ronald Pettus, who graciously opened his home to me to share his incredible personal collection of Lauderdale County images and artifacts. It was my great pleasure and honor to meet L.C. "Bill" Clemmons, Robert "Bob" Whitten, Charles Alexander, Steve Cooper, and Wayne Higgins; each of these men went out of their way to share their historic photographs and postcards. I was also happy to meet Janet Ragland of the St. Florian History Committee, who allowed the inclusion of photographs from the collection of Mary Ellen Stumpe Hall, and Amy Ezell Burzese of Rogersville, who, through Danny Tully, provided amazing images from the East Lauderdale community.

Finally, I would like to thank Brian Murphy of Pope's Tavern Museum, Teresa Garner of Rogersville Public Library, and Volodymyr Chumachenko of the University of North Alabama (UNA) Collier Library Archives and Special Collections for their assistance in gathering original images and Dr. Carrie Barske Crawford, executive director of the Muscle Shoals National Heritage Area and author of two Images of America books, for her authorial advice.

Many of the images in this book as well as much of the narrative can be attributed to the extensive and thorough research and writings of the late historian William Lindsey "Bill" McDonald and his vast collection of photographs, which were entrusted to UNA after his death in 2009. Lauderdale County was lucky to have had such a detailed and prolific person dedicated to preserving our history.

INTRODUCTION

The story of Lauderdale County begins not with its official creation on February 6, 1818, nor even with its settlement by the Chickasaw and Cherokee. Several ancient mounds, including the 43-foot-high Indian Mound at Florence, reveal the history of a people who hunted this land for prehistoric wildlife and gathered mussels from the mighty Tennessee River. By the time Spanish expeditions made their way here in the 1500s, these people had disappeared.

By the 18th century, French explorers, English traders, Creeks, and Shawnees had all ventured into the territory, but it was the Euchee, followed by the Cherokee and Chickasaw, who loved, nurtured, and held claim to this land. They came from the east and west, respectively, and were the first to greet the European speculators who began to appear in the late 1780s. Cherokee chief Doublehead and his son-in-law George Colbert, who was half-Scot and half-Chickasaw, called the areas both north and south of the "mussel shoals" portion of the river home.

Word of the area's fertile lands, temperate climate, and fish-filled waters spread quickly and, as local historian William "Bill" McDonald wrote in his book *A Walk Through the Past*, "then came the people." Some white settlers leased property in present-day east Lauderdale County from Doublehead; thousands of others squatted on the land without permission from its owners. In 1811, approximately 15,000 people called this "wilderness" home. Skirmishes, standoffs, and several treaties between the US government and the tribes followed. By the 1830s, the Cherokee and Chickasaw had ceded their claims to the land that is now Lauderdale County.

The February 1818 act of the first session of the General Assembly of the Alabama Territory established the county that would become the northwestern corner of Alabama when it became a state a year later. Lauderdale County included 100 miles of waterfront along the Tennessee River and roughly 444,000 acres of land. It was named for Lt. Col. James Lauderdale, who died in 1814 from injuries sustained during the Battle of Talladega in the War of 1812. Lauderdale served under Gen. John Coffee, who, as a member of the Cypress Land Company, became one of the first official land purchasers in the county. It is likely that Coffee suggested that the new county bear his soldier's name.

The seven trustees of the Cypress Land Company purchased and subsequently resold 5,515 acres along the Tennessee River; this land became the city of Florence. Other towns that were planned for the county, including Middleton in central Lauderdale and Jacksonburg on Cypress Creek, never materialized. County officials, based in Florence, were appointed by Alabama governor William Wyatt Bibb, and by 1821, four voting places and a militia had been established.

In the meantime, the areas outside the city limits of Florence were flourishing. Settlements that began well before the county was established continued to grow as more and more people flowed in along the Natchez Trace, which ran through western Lauderdale, and Andrew Jackson's Military Road, which entered the county near what is now Greenhill. Even more braved the rapids of the Tennessee River or forged their own paths to find a new home in Lauderdale County.

Pioneer Richard Rapier arrived before 1818 to trade with the Chickasaws and operate a fleet of keelboats. Jonathan Bailey moved here around 1813, purchasing hundreds of acres on which he

would build a famous health resort. Daniel White built a stagecoach inn east of Bluewater Creek in 1812 on a site previously occupied by Chief Doublehead. Samuel Savage settled in western Lauderdale County. Darbys, Paulks, and Fowlers blazed their way through the forest in 1816 to settle near Cloverdale. American Revolution veteran Samuel Burney came to the area now known as Rogersville as early as 1810. These men and their families, along with scores of others, founded communities across Lauderdale County.

Each of these settlements—from Anderson to Wright's Crossroads—developed its own personality based on its founders and its geographical features. Wealthier individuals established farming plantations in central Lauderdale along the many tributaries of Cypress Creek. Others found that the creeks, such as those running through Lexington, were ideal sites for water-powered mills, and mineral springs like those on Jonathan Bailey's land were conducive to health spas. The fertile land along the southern "bend" of the Tennessee River and south of Elgin proved perfect for growing cotton. Hiram Kennedy established a gun factory in Greenhill because its location along the Military Road provided the opportunity to sell weapons to travelers.

More people came to Lauderdale from across the United States as well as abroad, bringing with them their diverse heritage, skills, ideas, traditions, and religion. They established schools for their children and churches for their families. They built inns for visitors and stores for settlers. They became farmers, merchants, teachers, preachers, mail carriers, mill workers, tradesmen, and homemakers. For decades, the county thrived as its inhabitants capitalized upon its great potential.

Lauderdale County did not escape the destruction and tragedy of the Civil War. Although the majority of Lauderdale's young men who volunteered or were conscripted fought for the Confederacy, several joined the Union forces. As the war progressed, Union troops encamped at various locations across the county, including at the Bailey Springs resort, and skirmishes took place at Center Star, Happy Hollow, Lamb's Ferry, Waterloo, and other locations. The Confederate army burned the railroad bridge to prevent Union soldiers from easily crossing the river, and Union forces burned homes and factories. However, when the smoke began to clear in 1865, the people of Lauderdale County rebounded and rebuilt.

A new century dawned on a prosperous Lauderdale County of 26,559 people. Families from across the county sent their sons to war in 1917 and again in 1941; many of these brave men did not return home.

Three attempts were made to tame the treacherous Tennessee River to allow for safe commercial navigation. The Muscle Shoals Canal, begun and abandoned in the 1830s, opened successfully in 1890 but was eclipsed by the completion of Wilson Dam in 1924. The Tennessee Valley Authority's construction of Pickwick Dam and Wheeler Dam changed the landscape of Lauderdale County, relocating families, cemeteries, and roads and drowning a portion of the town of Waterloo but creating new avenues for commercial navigation.

Today, the close-knit neighborhoods of Lauderdale County continue to thrive and grow within and outside the city of Florence. Towns include Anderson, Killen, Lexington, Rogersville, St. Florian, and Waterloo, while Underwood-Petersville is a census-designated area. Citizens proudly claim their homes and heritage in the unincorporated communities of Bailey Springs, Center Star, Cloverdale, Elgin, Grassy, Greenhill, Mars Hill, Oakland, Rhodesville, Smithsonia, Stewartville, Threet, Wright, and Zip City. Descendants of those who founded or first populated these communities still live where their ancestors did five, six, and seven generations ago.

The beauty and quality of life in Lauderdale County along the Tennessee River is not a well-kept secret; people are still flowing in and making their new home here just as they did more than 200 years ago. We are still farming and fishing, manufacturing and ministering, boating and baptizing, and learning and living well. We, the people of Lauderdale County, are still adding chapters to the story told within these pages.

One

LORE OF THE RIVER

As the late Lauderdale County historian William McDonald wrote in his book *Lore of the River*, the history of the people here is also the story of the great Tennessee River. From the mighty long-ago shoals at Florence to the creeks that wind throughout the county as seen in this 1858 map, Lauderdale's waterways have been the backdrop for citizens' lives . . . and lore. (Courtesy of Tennessee State Library and Archives.)

The Muscle Shoals Canal was first authorized in 1831 to circumvent the treacherous rapids of the Tennessee River and enable commercial navigation. Despite the completion of 17 locks, the project was abandoned in 1838. Renewed interest in river travel after the Civil War revived the endeavor in 1873. Lt. George W. Goethels, who later engineered the construction of the Panama Canal, led the project from 1888 to its completion in 1890. Laborers widened the existing canal to 70 feet, built three dams (including the one at Bluewater Creek shown in the 1877 photograph above), and constructed nine locks, including Lock Six, shown below. (Above, courtesy of US Army Corps of Engineers; below, courtesy of Ronald Pettus.)

Maj. William Rice King, the second engineer to manage the second Muscle Shoals Canal project, conceived the idea of installing a 14-mile-long railroad track along the canal route for use during construction as well as after completion. Steam locomotives like this one at Lock Four transported workers and supplies, towed boats through the canal, and even temporarily supplied power to operate the lock gates. (Courtesy of Pope's Tavern Museum.)

The great volume of water pouring into the canal from Shoal Creek necessitated the construction of an 845-foot-long and 60-foot-wide aqueduct. A true feat of engineering, the steel aqueduct, supported by two abutments and 25 masonry piers, allowed boats to travel roughly 20 feet above the canal, giving them the appearance of being airborne. (Courtesy of University of North Alabama Archives.)

The bustling reservation at Lock Six included workers' quarters, offices, a commissary, coal and meat houses, gardens, and a stable in addition to operational necessities such as a shipyard, carpenter shop, and sawmill. Barges were built and launched, and boats were repaired, all in the dry dock shown above. Drains under the canal and railroad kept the dock dry. Workers at the sawmill pictured below transformed logs, which had been floated down the river as rafts, into lumber for the canal's construction. Scrap lumber and bark fueled the sawmill's boiler and the kiln used for drying wood. A water-powered dynamo generated power for the facility. (Above, courtesy of US Army Corps of Engineers; below, courtesy of Ronald Pettus.)

The shoals of Elk River, a tributary of the Tennessee River, also required the construction of a three-and-a-half-mile-long two-lock canal to aid in safe recreational navigation of river traffic, including steamboats like this one. This image of the steamboat *American* was taken at Lock A at the Elk River Shoals near Melton's Bluff. The *American* was built in Decatur, Alabama, in 1901 by American Oak Extract. (Courtesy of Ronald Pettus.)

The first steamboat to arrive at the Florence port in March 1821 was the *Osage*. It was loaded with provisions from New Orleans, including coffee, sugar, iron, and nails. More steamboats followed; 20 were in service on the lower Tennessee by 1830, and by 1901, a total of 271 steamboat landings were logged between Florence and Paducah, Kentucky, where the Tennessee joins the Ohio River. (Courtesy of Lee Freeman.)

Anderson Grist Mill, built in 1839, was one of the longest-running mills in the county. The town in which the mill is situated as well as the creek that powers it were named after the mill's founder, Samuel Anderson, who settled in the area in 1809. This image of the mill was taken in 1900. (Courtesy of University of North Alabama Archives.)

Sharp's Mill was located on Little Cypress Creek at White's Lake. The mill property, owned by Jim Sharp, included the gristmill and a cotton gin, barn, and wool carder. A 1902 flood washed away the operation, but Sharp rebuilt. The name *Sharp's Mill* was adopted as the name for the community as well as the road on which it was located. (Courtesy of University of North Alabama Archives.)

Richardson's Mill was located near Center Hill on Bluewater Creek. It was used as a gristmill, sawmill, and cotton gin. Although the photograph shows the mill in 1900, the first Richardson's Mill at this location was most likely built by John David Richardson, who died in 1847. (Courtesy of Ronald Pettus.)

At one time, Burcham Mills was the site of a gristmill, blacksmith shop, and a cotton gin. Although the gin relocated to the Threet's Crossroads area, the mill is thought to have remained in its original location on the south side of Burcham Creek in the Central Heights community until after World War I. (Courtesy of University of North Alabama Archives.)

Named for the huge trees that shade its clear and clean waters, Cypress Creek flows in a southerly direction through the center of the county from the state of Tennessee to the Tennessee River. Cypress Creek's picturesque setting makes it a favorite spot for picnics, leisurely strolls, bird and wildlife watching, fishing, canoeing, and kayaking. Low dams and the ruins of former cotton mills and gristmills still dot the creek, reminding visitors of the industrial roots in Cypress. These photographs were taken in the summer of 1894 in the Gunwales Ford (now Gunwaleford Road or County Road 2) area near Savannah Highway. (Both, courtesy of Ronald Pettus.)

The pumping station on Cypress Creek, shown here during construction in 1916, was a key part of Florence's water filtration system. Upon completion, millions of gallons of water were drawn into the pumping station, filtered, and fed to the 70-foot-high, 300,000-gallon capacity water tower in the photograph at right. Water from Cypress Creek ran through miles of mains under the city streets and into hundreds of fire hydrants. The new pumping station replaced the original 1890 plant, which was purchased in 1916 by the city from Florence Water Works, a private company. The water tower, built in 1889, is listed in the National Register of Historic Places and still stands on Seymore Avenue in North Florence. (Above, courtesy of Florence-Lauderdale Public Library; right, courtesy of Ronald Pettus.)

Wilson Dam provides hydroelectric power to the Tennessee Valley and tames the turbulent Tennessee River at Lauderdale County. The dam and its lock system replaced the Muscle Shoals Canal, a previous attempt to make the river more navigable, and submerged the canal's nine locks. Construction of Wilson Dam began in 1918 with the building of cofferdams like the one above, shown here in August 1919. Water was drained from the area between these dams to prepare a dry surface for Wilson Dam's concrete foundations. The image below from October 1919 offers a glimpse of the rushing waters, some of the workers' camps, and Jackson Island, which is now just downstream of the dam. (Both, courtesy of the US Army Corps of Engineers.)

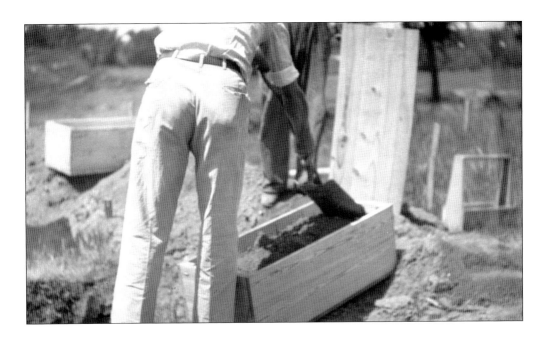

In preparation for the construction of Pickwick Dam, 52 miles downstream from Wilson Dam, the Tennessee Valley Authority worked to relocate homes, farms, roads, utilities, and cemeteries that would be flooded when the dam was completed in 1938. In total, 506 families in four counties were impacted. The town of Waterloo in Lauderdale County was partially flooded, but its citizens rallied, creating a thriving riverside community with a rich, unique history. These images show the careful disinterment (above) of graves at Waterloo and reinterment (below) to a parcel of land donated to the town by the Richardson family. These were among the nearly 20,000 total graves relocated by Tennessee Valley Authority in accordance with state laws and the wishes of next of kin in the 1930s. (Both, courtesy of National Archives.)

Wheeler Dam, located 15 miles upstream from Wilson Dam, was completed by the Tennessee Valley Authority in 1936. More than 30,000 acres of land had to be cleared to prepare for creation of the reservoir. The Wheeler Reservoir cleaning crew, pictured here in 1935, was among the 4,700 people who worked on the Wheeler Dam project. (Courtesy of University of North Alabama Archives.)

Wilson Dam was completed by the US Army Corps of Engineers in 1927 with a double-lift lockage system. In 1959, the original lock was replaced with a main single-lift lockage system, the highest single-lift lock east of the Rocky Mountains. Pictured here in 1958 are the supervisors in charge of the new lock's construction. (Courtesy of Rogersville Public Library.)

During World War II, Wilson Dam served as headquarters for the Tennessee Valley Authority's agricultural and chemical programs. Power from the dam was used to operate nitrate and phosphorus factories that supplied munitions operations. Workers like those pictured above in 1942 and below in 1943 filled a variety of vital operational and maintenance roles, including welders, engineers, turbine operators, pipefitters, electricians, and laborers. In 1942, men with experience in heavy construction, timber, and logging operations were hired to clear land in preparation for the raising of the pool level on the Wilson Reservoir. Even today, the operation of Wilson Dam requires employees with a wide variety of skills and areas of expertise. (Above, Library of Congress; below, courtesy of Rogersville Public Library.)

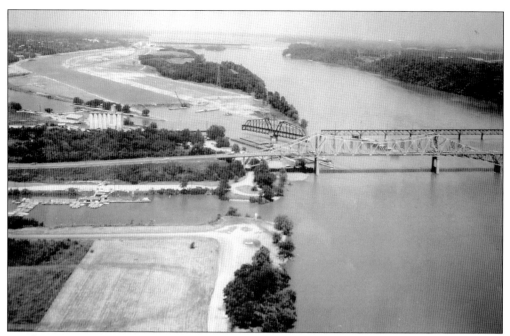

Just downstream from Wilson Dam, the waters near O'Neal Bridge have long been a hub of activity. River-related industrial and cargo operations take place in Florence Harbor east of the bridge, while the west side is used for more recreational pursuits. This area is home to O'Neal Harbor and McFarland Park, land which was once owned and farmed by Will McFarland. (Courtesy of University of North Alabama Archives.)

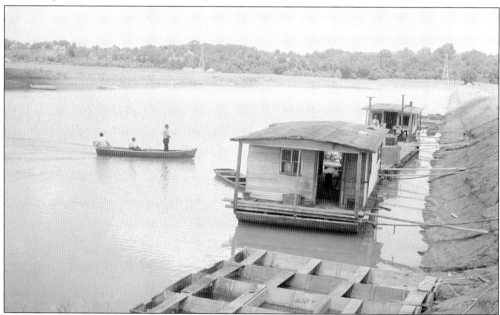

Houseboats, like these anchored in O'Neal Harbor, often served as temporary or permanent homes for individuals and families. The boats could be quite large, with multiple bedrooms and living areas. Throughout the first half of the 20th century, houseboats could be found all along the banks of Lauderdale County waterways, including Cypress Creek. (Courtesy of National Archives.)

O'Neal Harbor and O'Neal Bridge were named in honor of Edward A. O'Neal and his son Emmett O'Neal, who were both Lauderdale County farmers, local leaders, and governors of Alabama. The harbor was formed when land was excavated to build up the bridge's north approach in 1939. These photographs from 1949 show the harbor full of activity. Sport and leisure boats of all sizes line the banks, while fishermen and their boats stop at the floating bait shop owned by Buddy McDonald. O'Neal Harbor was also the longtime site of annual Labor Day celebrations featuring water shows and speedboat races. Beyond the harbor is farmland owned until the late 1930s by Will McFarland, a farmer, professional baseball player, and attorney. McFarland's property was later developed into McFarland Park. (Both, courtesy of Florence-Lauderdale Public Library.)

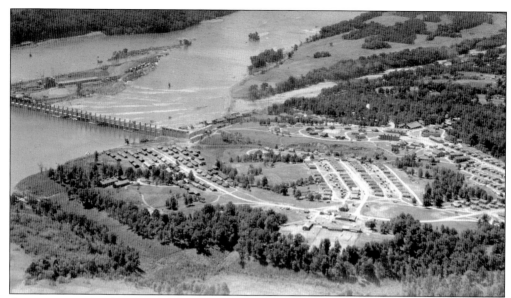

Construction of Wilson Dam was a monumental project. It required the excavation of nearly 1.5 million cubic yards of earth and rock and required 1.3 million cubic yards of concrete. From 1918 to 1927, the areas just north and south of the dam were populated by more than 18,000 workers and their families in self-contained communities. The construction site included 1,700 temporary buildings, 236 permanent buildings, 185 residential units, 23 mess halls, a school for 850 students, an 85-bed hospital, and 3 barbershops. The image above from 1924 offers a bird's-eye view of the Lauderdale County construction site, while the photograph below from the late 1930s shows the remaining vestiges of the Colbert County worker community. (Above, courtesy of National Archives; below, courtesy of Ronald Pettus.)

Two

TRAVERSING THESE 721 SQUARE MILES

Lauderdale County has long served as a gateway to larger cities to the north, east, west, and south. Railways crisscrossed the county, and bridges facilitated travel across the river, streams, and creeks, which were also transportation routes. Shown in 1914, roads like this one, the post road six miles east of Florence, required constant inspection and maintenance. (Courtesy of National Archives.)

The first bridge connecting Lauderdale and Colbert Counties was opened in 1840 by the Florence Bridge Company. It was constructed of heavy timbers placed on wooden pilings and facilitated railway traffic until 1853 when it was destroyed by a cyclone. Rebuilt in 1858 by the Memphis & Charleston Railroad, the new bridge was open to the public for both train and wagon travel and foot traffic. This second effort was destroyed by the Confederate army during the Civil War but was rebuilt in 1870. Ownership of the bridge changed hands multiple times before it was permanently closed to traffic in 1980. (Both, courtesy of University of North Alabama Archives.)

101. Railroad and vehicle bridge across the Tennessee River 3½ miles below Wilson Dam between Florence and Sheffield.

For several years beginning in the 1890s, the bridge connecting Lauderdale and Colbert Counties was owned by the Southern Railway company. Trains from that line, like the one shown above in Florence, brought a growing number of visitors from Colbert County. Tolls for crossing the bridge in 1900 ranged from 2¢ per head for hogs and goats to 60¢ for a six-horse wagon. Around 1930, the crew below worked on the Louisville & Nashville Railroad (L&N), which served Florence and had a depot in east Florence. The tall man standing fifth from the left in the overalls with the watch chain has been identified as Charlie Miller. (Above, courtesy of Ronald Pettus; below, courtesy of University of North Alabama Archives.)

#77.

WILSON DAM, TENNESSEE RIVER.

Derailment of locomotive #13 in the upper end of lock (earth) excavating work.
Henry Vanhoose # 2096, a colored laborer, was fatally injured in this wreck.

December 3, 1919.

Rail travel could be dangerous, as illustrated by this image of a fatal 1919 locomotive derailment during the construction of Wilson Dam. This was not the only train-related death in Florence in 1919. However, in 1924, the L&N Railroad proclaimed that railways were safer than streets, with derailments and collisions claiming only one life per day compared to 38 per day who died from auto accidents. In 1940, L&N advertised that it had operated continuously for 22 years without a single fatality. Today, some of the original tracks from the railroad used during the construction of Wilson Dam can still be found along the Muscle Shoals National Recreational Trail on the Tennessee Valley Authority reservation. (Courtesy of US Army Corps of Engineers.)

Streetcar service across the Florence Bridge began in 1904 at a rate of 20¢ per passenger; the rate was reduced to 10¢ in 1909. These images from 1908 show a streetcar packed with passengers and folks waiting on the streetcar on the Sheffield side. A sign warns traffic not to exceed 15 miles per hour. The roadway/pedestrian walkway under the railway is also clearly visible. Streetcar service ended in 1933, and when O'Neal Bridge opened in 1938 as a toll bridge, all non-railroad traffic on the Florence Bridge ended. (Both, courtesy of University of North Alabama Archives.)

In 1962, the Tennessee Valley Authority placed a 406-foot vertical lift mechanism on the north side of the Florence Bridge. This span could rise to a 350-foot clearance to allow river traffic to pass underneath. Previously, this function was served by a drawbridge and later by a pivot span with a 100-foot clearance. Conway Graden, a steamboat captain and Wilson Dam lockmaster, looks on. (Courtesy of US Army Corps of Engineers.)

Tennessee River at Florence, Ala.

Now known simply as the Old Railroad Bridge, the former Florence Bridge no longer spans the entire Tennessee River. As rail service declined in the 1970s, the lift portion was mostly left unattended and in a raised position. The lift was finally removed in 1992 to be reused in Hannibal, Missouri. Today, the lower portion of the southern approach has been preserved as a pedestrian walkway. (Courtesy of Robert Whitten, architect.)

The bridge over Elk River on Highway 72 near Rogersville connects Lauderdale County with Limestone County to the east. Built by the Tennessee Valley Authority in 1934 at a cost of $500,000, the new structure replaced a wooden bridge that stood roughly 100 yards downstream and was submerged with the opening of Wheeler Dam in 1936. In 1997, the bridge was renamed in honor and memory of Henry E. Hamilton, late brother of Rep. James H. "Goat" Hamilton, a native of Rogersville. Henry Hamilton died in a car accident near Rogersville in 1967 at the age of 47. (Both, courtesy of Rogersville Public Library.)

This three-truss bridge spanned Shoal Creek on Lee Highway, then known as the old Huntsville Road, as early as 1881, when lumber was removed from the bridge and replaced. In 1890, county commissioners authorized $7,725 in repairs to the bridge after it was washed away by floodwaters. Another major repair was completed in 1899. The bridge was finally dismantled in November 1924. (Courtesy of University of North Alabama Archives.)

Construction on a new Shoal Creek bridge began in the summer of 1924. In the midst of this effort, the former bridge was inundated by rising floodwaters, and authorities were forced to contract with a ferry service to transport travelers across the creek until the new, higher bridge was opened to traffic. (Courtesy of Ronald Pettus.)

New Steel Bridge at Shoals Creek

The five-truss, two-lane, steel-and-concrete Shoal Creek bridge opened to traffic in November 1924, rising 100 feet above the waterline, well above flood level. After Lee Highway was converted to four lanes in the late 1950s, another two-lane bridge was constructed next to this one to accommodate the increased traffic. This addition was relatively short-lived, however, as the construction of a six-lane bridge in 2007 replaced both the 1924 and 1950s spans, and the latter was removed. The original 1924 Shoal Creek bridge was preserved but gated to block pedestrians and other traffic. (Both, courtesy of Robert Whitten, architect.)

SHOALS CREEK—CREATED BY THE BACKWATERS OF WILSON DAM, MUSCLE SHOALS, ALA.

This bridge, thought to have been named Shellrock Bridge, was typical of the structures built to span Lauderdale County's many creeks around the turn of the 20th century, many of which were often washed away by floodwaters. Notes on this photograph, taken in 1902, indicate that the bridge crossed Bluewater Creek on Highway 33 south of the Center Hill community. (Courtesy of Ronald Pettus.)

Wooden bridges like this one on the Waterloo post road 7.5 miles west of Florence were often constructed across streams, smaller creeks, and gullies. They required a great deal of maintenance to allow safe passage for travelers. When this image was captured in 1913, automobiles were not yet prevalent in Lauderdale County, as most were owned by wealthy individuals in larger cities. (Courtesy of National Archives.)

Cypress Creek Bridge, 1915 Waterloo Road

This bridge, shown here in 1915, crossed Cypress Creek on Waterloo Road near what is now Wildwood Park. The plaque at the top of the iron bridge shows it was built in 1902 by the Converse Bridge Company, replacing a bridge that was one of five destroyed by a flood earlier that year. (Courtesy of University of North Alabama Archives.)

WATERLOO FERRY

Waterloo lies across the Tennessee River from the former Colbert County community of Riverton, which was submerged with the completion of Pickwick Dam in 1938. Before then, travelers could use the Waterloo Ferry to cross the river into Riverton, as these folks were doing here in the early 20th century. (Courtesy of Florence-Lauderdale Public Library.)

The town of St. Florian was founded in the late 1870s by German Catholic farming colonists from all over the eastern United States. Andrew Jackson's Military Road, known today as County Road 47, runs through the heart of the town, as does Church Road on which St. Michael's Catholic Church stands. This road in St. Florian is unidentified, yet it could be either of these. (Courtesy of St. Florian History Committee.)

Many early roadways were often known as "post roads" because they were designated for the transportation of postal mail. Lee Highway, portions of which are now known as Highway 72, was once called the Huntsville Post Road. This image was taken on the Huntsville Post Road, 6.25 miles from Florence, looking east toward Killen. (Courtesy of National Archives.)

Three

ACTIVITIES AND AMUSEMENTS OF THE DAY

Lauderdale County's comfortable climate and plentiful waterways provide endless opportunities for entertainment and outdoor activities. Here, Carl Rand (third from left) and John David "Mickey" Gibbons (far right) show off their catch from a Tennessee River fishing trip to Buddy McDonald (far left) and an unidentified man and woman in 1952. Rand, Gibbons, and McDonald were lifelong friends who also enjoyed participating in speedboat races near O'Neal Harbor. (Courtesy of Robbie Gibbons and Angela Bryant Hendrix.)

BAILEY SPRINGS, FLORENCE, ALA.

Bailey Springs was a popular antebellum resort located nine miles east of Florence on the banks of Shoal Creek. Jonathan Bailey purchased the land on which the resort was built in 1818. After some of Bailey's physical ailments were supposedly cured by the mineral springs on his property, he invited others to his home to "take the waters." The springs became so popular that Bailey built a hotel to accommodate his many visitors from throughout the United States. Although Bailey died in 1857, a succession of owners continued to add facilities and host activities at the growing resort. Federal troops invaded and vandalized much of the resort during the Civil War, but the owners quickly refurbished the facilities and reopened. At the peak of its popularity, Bailey Springs welcomed thousands of visitors each summer, with two stagecoaches and eight carriages operating between Florence and the spa. By World War I, the resort had fallen into disrepair and was permanently closed. (Courtesy of Robert Whitten, architect.)

Bailey Springs resort was a popular summer destination for locals and out-of-state visitors alike. In addition to the healing springs, over which were built springhouses like the one above, the resort's amenities included a spacious ballroom, bowling alleys, billiards, barrooms, dining areas, a clubhouse, an auditorium, private log cabins, and at least four two-story hotel structures. The resort hosted picnics, dances, concerts, and other performances, like the recitation of "The Soldier's Joy" by Nannye "Nan" McDaniel of Forrest City, Arkansas, who danced the reel to this popular tune at Bailey Springs in 1894. McDaniel was a student at Bailey Springs University, which stood on the resort grounds and was open to women from 1893 to 1900. (Above, courtesy of University of North Alabama Archives; right, courtesy of Florence-Lauderdale Public Library.)

The site of the sixth of the nine locks of the Muscle Shoals Canal became a recreational destination. Families and groups would travel to the Lock Six Reservation by road or steamboat to enjoy the beauty of the grounds, which consisted of several acres of rolling hills surrounded by a white picket fence. Several buildings dotted the area, including the homes of the engineer-in-charge and second-in-charge and their families, offices, workers' quarters, and stables. Trailing red roses climbed the wide porches of several of these structures, and most were painted white with green trim. The beautifully landscaped reservation offered a gorgeous backdrop for photographs like these. (Both, courtesy of Ronald Pettus.)

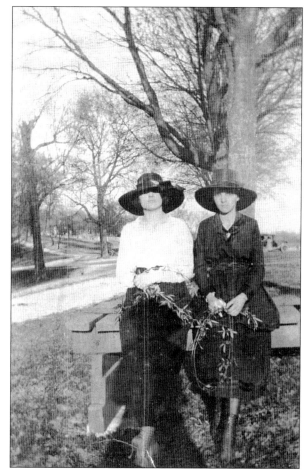

The lovely old trees, sloping lawns, and flower and vegetable gardens of the Lock Six Reservation prompted Joshua Nicholas Winn III, who lived at the reservation while his father served as the lock's second engineer, to refer to the grounds as the "Garden of Eden." These natural features complemented carefully man-made structures like the arched bridge seen in both these images. At right, Bess (Stutts) Cox and Mae Jones pose with the bridge in the background, while the family of Prof. E.A. Henry of Florence Normal College (now the University of North Alabama) is pictured on the 1909 postcard below. (Right, courtesy of Ronald Pettus; below, courtesy of Robert Whitten, architect.)

The Wesley Chapel community, originally known as Huggins, was one of the earliest settlements in Lauderdale County. Early landowners were John Huggins, Alexander Faires, Sam Savage, Joseph German, John Spain, and William Smart. Some other families who settled here included Youngs, Haddocks, Jacksons, Bevises, Darbys, Broadfoots, and Dowdys. The area, located in the west part of the county near Cloverdale, Central Heights, and Young's Crossroads, is home to Wesley Chapel United Methodist Church and its adjoining cemetery on County Road 15. The first interment in the cemetery was recorded in 1819, while the first church service was held in 1816 in an early log schoolhouse on land that the current church occupies. The church often hosted large gatherings of folks from around the county, including religious discussions, Sunday school conventions, and a teachers' institute. Pictured here in 1919, the Wesley Chapel community gathers to welcome home local soldiers who served in World War I. Although World War I began in 1914, the United

States did not join the fighting until the spring of 1917. In all, more than 86,000 Alabamians fought in the war, and more than 2,500 perished. A total of 1,135 individuals from Lauderdale County served, including 956 soldiers in the Army, 55 sailors in the Navy, and 11 Marines. There were also 13 fraudulent enlistments, discharges, dishonorable discharges, or desertions. Forty-six enlisted men from Lauderdale County died in the war. It impacted Lauderdale County in other ways as well. For example, a steady stream of nitrates needed to support the war effort resulted in the construction of two nitrate plants near Wilson Dam. The plants went into production in 1918 but went idle and were fenced off just three years later. After the war ended on November 11, 1918, civic organizations joined forces to raise funds to send to Lauderdale County enlisted men who were still overseas. (Courtesy of University of North Alabama Archives.)

Boy Scout Troop 7 Woodpigeon Patrol was organized in 1925 with eight members. By 1929, when the troop received its fourth official charter, it had grown to 43 members, most from the East Florence community. Raymond Murphy served as scoutmaster when this photograph was taken in 1928. (Florence-Lauderdale Public Library.)

Boy Scout Troop 53 was founded in Killen in the 1920s with John Cox as scoutmaster. This troop from 1954 poses in front of Killen Methodist Church, where Brooks Elementary now stands. The church sponsored the troop and allowed them to meet in the basement for years. Briton Pettus (left) was scoutmaster, and Ronald Pettus, who owned the dog, Buster, is seated third from left in the second row. (Courtesy of Ronald Pettus.)

Camp Westmoreland, the oldest continuously operating Boy Scout camp in Alabama, boasts 4,100 feet of Shoal Creek waterfront among its 284 acres. Located eight miles northeast of Florence, Camp Westmoreland was North Alabama's main Scout summer camp for 50 years. More than 70,000 Scouts have used the property for camping, archery, swimming, and other recreational activities, including the boys pictured here who visited one month after the camp opened in June 1929. The camp has hosted famous visitors, including singer Gene Autry, and is named in honor of J.E.F. Westmoreland, who donated the property's original 44 acres to the Andrew Jackson Council, Boy Scouts of America, now known as the Greater Alabama Council. (Both, courtesy of University of North Alabama Archives.)

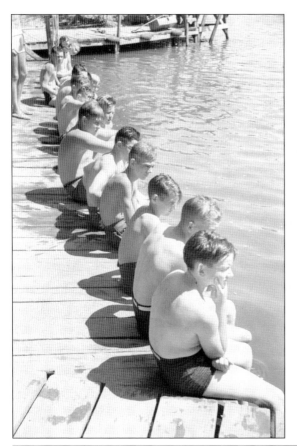

In the summer of 1942, Camp Westmoreland was open for five one-week periods beginning June 29. Camp director was W.J. Terry, who was also the principal of Morgan County High School in Hartselle, and Eagle Scout Jack Patterson of Troop 14 in Huntsville served as waterfront director. Sixty Scouts from troops across north Alabama attended during the first week of 1942 to participate in camping, outdoor cooking, and the Battle of Camp Westmoreland, a staged battle among two "armies." On Sunday, July 5, campers participated in a water carnival, which was captured by renowned photographer Jack Delano. The carnival included swimming and boating races and diving contests in Shoal Creek, all supervised by Patterson. (Both, Library of Congress.)

Camp Westmoreland's water frontage on west Shoal Creek provided opportunities for campers to enjoy rowboats, canoes, and cruises in addition to swimming and diving. All water activities were supervised by the waterfront director and several trained lifeguards were on duty. Boy Scouts attending Westmoreland's annual summer camps were inundated with activities; they practiced archery and campfires, erected tents, created crafts, and hiked the vast acreage. The property also included permanent cabins, tennis courts, a baseball field, a mess hall, and a library. Westmoreland is famous for its Westmoreland Winds and Good Camper pin/medal award system. The camp was placed in the Alabama Register of Landmarks and Heritage in 2006. Although primarily a Boy Scout camp, local 4-H and Rotary clubs and chaperoned groups of girls also spent time at Westmoreland. (Library of Congress.)

Shady Rest Tourist Camp, located in Killen on what is now Highway 72, was owned and operated by the J.W. Carter family and thus was often called Carter's Camp. Locals and visitors alike enjoyed the camp's 16 acres of cottages, shaded picnic areas, playgrounds, and pools. Shady Rest was known for Tuesday and Saturday night dances and the onsite restaurant as well as its minnow pool and proximity to Wilson Lake for fishing. Above, Ora Scarbrough stands at the Shady Rest fence while an unidentified woman in an innertube bathes in the pool in the image below. (Both, courtesy of Ronald Pettus.)

J.W. Carter and his wife opened Shady Rest Tourist Camp in 1927 and immediately attracted a variety of groups from Florence, including nurses from Eliza Coffee Memorial Hospital and students from Florence Normal College, for weekend parties and picnics. The unidentified young lady above is posed in front of the Shady Rest Sandwich Shop, which was open 24 hours a day for ice cream, cold drinks, special-ordered dinners, candies, and tobacco. In the image below, Hiram Phillips and Rena Scarbrough (in the pool) join proprietor J.W. Carter (left) at the Shady Rest pool with Lee Highway (later Highway 72) in the background. (Both, courtesy of Ronald Pettus.)

The current University of North Alabama softball field location at the corner of Chisholm Road and Cox Creek Parkway is the former home of the North Alabama State Fair, which is now held at the fairgrounds in Muscle Shoals. More than 2,000 people attended the first fair held here in 1935. The fairgrounds were also home to the Florence Raiders baseball team in the spring and summer, as seen above. Crystal Plunge, a large community pool that operated from the 1930s into the early 1950s, was also on the grounds (below). (Above, courtesy of University of North Alabama Archives; below, courtesy of Danny Hills.)

Home sweet home offered plenty of amusement for Lauderdale County families, especially when they gathered together for fun photo opportunities like this one. Gathering on a wagon and a bale of hay at their farm near Cloverdale are members of the family of matriarch Martha Josephine "Josie" Freeman. From left to right in the above photograph are Emery Freeman, Allen Freeman, Mary May Freeman, Eliza Beckham, Vernon Freeman, and Earl Freeman. From left to right in the below photograph are Allen, Eliza, Josie, and three unidentified. Shortly after these images were taken, both Allen and Emery Freeman served as members of the US Army Expeditionary Force in France during World War I. Vernon finished basic training just before the armistice was signed; Earl died of pneumonia at age 18 in December 1918. (Both, courtesy of Lee Freeman.)

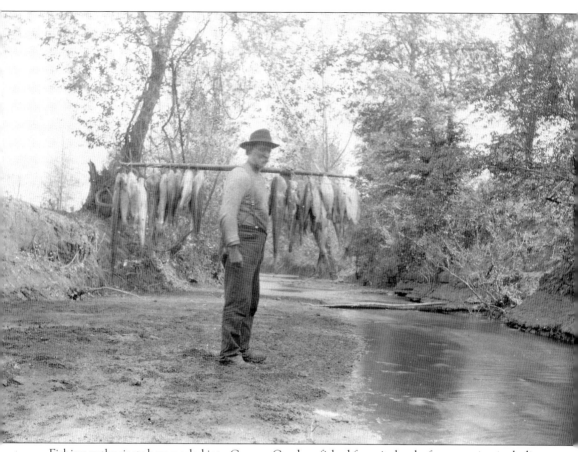

Fishing enthusiasts have waded into Cypress Creek or fished from its banks for centuries, including this fisherman who strung his impressive catch along a pole for easy transport after a successful day on the creek in May 1915. Cypress boasts a diverse fish population, including smallmouth bass, largemouth bass, spotted bass, rock bass, bluegill, and longear sunfish. Cypress is also known for its excellent water quality and has become a popular route for kayakers, canoers, and tubers. During the antebellum period, the creek powered all sorts of mills, including cotton mills, gristmills, and lumber mills. Most sections of the creek are ideal for swimming and wading as well. Several Lauderdale County creeks flow into and merge with Cypress, including Threet Creek, Little Cypress Creek, Middle Cypress Creek, Cox Creek, and the North Fork. The path of Cypress Creek also crosses significant roads and properties, including the Natchez Trace and the Forks of Cypress plantation. (Courtesy of Ronald Pettus.)

These men seem to have had a successful day of fishing on Pickwick Lake just below the spillways of Wilson Dam in 1940. This spot on the Tennessee River, known as the Wilson Dam tailwater, offers excellent sportfishing and is noted for producing record-size smallmouth bass and catfish. The tailwater creates ideal conditions and lots of food for the bass and other species downstream. Smallmouth bass love the rushing water released by the spillways. Also, by releasing water from the bottom of the Wilson Reservoir, the tailwater features relatively consistent water temperatures year-round. The tailwater section has gained a nationwide reputation for producing record-size fish, including a 52-pound, 12-ounce paddlefish in 1982; a 14-pound, 14-ounce silver redhorse in 1995; a five-pound, two-ounce sauger in 1972; and a 19-pound, 8-ounce muskie in 1972. Both Wilson and Pickwick Lakes have become widely known as prime fishing spots, leading to Lauderdale County's popularity as a location for professional and amateur fishing tournaments. (Courtesy of National Archives.)

The Tri-Cities Speedway was located on Cloverdale Road at the current site of the county landfill and offered racing events in the late 1950s, closing in 1959. During the racing season, the track attracted professional and amateur stock car drivers, car owners, and their crews of mechanics as well as hundreds of spectators who paid $1 admission. Wrecks (without serious injuries) could be quite entertaining. In the above image, Malcolm Brady climbs atop car No. 1190, which was owned by Noah Young of North Florence Wrecking Company and driven by K.C. Richards. The track was managed by Raymond Berkey, who is seen in the image below awarding the midseason championship trophy to Richards. (Both, courtesy of Steve Cooper.)

Students at singing schools are taught to sight-read vocal music. These schools were popular in the South, and Lauderdale County was no exception. Dozens of singing schools were held in the rural communities and taught by traveling or local singing masters. It became tradition to take a group photograph at the end of the school session, often in front of a sign or chalkboard naming the location, date, and teacher. Although no such sign is present in the image above, it is believed to be a class at Pisgah Church near Cloverdale. The Modern School of Music, seen below on July 24, 1922, was held in the Bethel community under the direction of Prof. C.A. Brock of Tennessee. (Both, courtesy of Ronald Pettus.)

Several small bands like this one, the Smithsonia Band, played throughout Lauderdale County in the late 1890s. In 1896, the Smithsonia Band consisted of 12 men, including J.T. Reeder, George Hipp, Albert McKelvey, Ed Hamm, Jack Hamm, Walter Hamm, Charles Smith, Tom Smith, Reuben Reeder, and Walter Stahl. The band would occasionally travel by band wagon into Florence for concerts at various locations, including the fairgrounds and the city park (now known as Wilson Park). Bandleader John T. Reeder owned the Smithsonia-area retail store shown in the photograph. Reeder was one of Lauderdale County's largest landowners, owning the Smithsonia estate, which was built by his father-in-law Columbus Smith, and Koger's Island, now owned by the Tennessee Valley Authority, where three indigenous mounds were once located. Reeder was a director of the First National Bank of Florence and vice president of St. Louis & Tennessee River Packet Company. He was a Mason, Elk, Knight of Pythias, and a member of the Exchange Club when he died in 1923 at the age of 60. (Courtesy of Lee Freeman.)

Joe VanSandt and Clyde Anderson started WJOI radio station in 1946. The station was housed in a small building on South Court Street in Florence and specialized in news and gospel music. In this image, Rita Janelle McNutt and an unidentified man perform live at WJOI in the 1940s or 1950s. (Courtesy of Lee Freeman.)

The Lauderdale County Jail might be an unlikely place to be discovered as a musician, but that's what happened to Jerry Morrison, 21. When Morrison was sentenced in 1972 to 18 months in jail for moonshining, Lauderdale County judge Ron Duska recognized his talent and arranged for an audition at a Sheffield recording studio. (Author's collection.)

Brothers Herbert and Guy Cox operated a garage on the ground floor of this structure, which was built about 1920 by Ulmer Roberts on the south side of J.C. Mauldin Highway just west of South Bridge Road in Killen. The members of Masonic Lodge 788 met on the second floor before purchasing their own building on Jones Avenue in 1930. (Courtesy of Ronald Pettus.)

Founded in 1883, Woodmen of the World was a fraternal organization that also provided life insurance for individuals who previously would not have been covered. Much like the Freemasons, members of Woodmen camps like Florence's Camp 8 met regularly to discuss business, held hierarchical positions, and practiced a variety of formal ceremonies, including the installation of a Woodmen monument at members' gravesites. (Courtesy of Ronald Pettus.)

Four

HARD WORK AND AN ENTERPRISING SPIRIT

Lauderdale County was built and grown by industrious individuals—farmers who tirelessly worked the land, entrepreneurs who started small businesses, and the tradesmen who provided skilled services. This St. Florian tack room owner likely counted the hardworking farmers of the German Catholic community as his loyal patrons. (Courtesy of the St. Florian History Committee.)

Edward A. O'Neal III, grandson of Alabama's 28th governor, chose a life in agriculture rather than politics. He joined the Alabama Farm Bureau Federation in 1921, serving as its president from 1931 to 1947. This image shows individuals working on the O'Neal farm property on County Road 2 (Gunwaleford Road), which was farmed continuously for generations. (Courtesy of University of North Alabama Archives.)

Dr. Shaler S. Roberts Sr. was a physician in Florence who owned the historic Woodlawn home and farm on Waterloo Road in the early 20th century. In April 1936, Roberts was photographed at his farm by the Tennessee Valley Authority to show the "starved and nourished" portions of his fields. (Courtesy of National Archives.)

From 1935 to 1944, the Farm Security Administration was one of several government agencies to photograph Americans at work across the country. In 1942, it photographed west Lauderdale County farmer Julien Case (left), seen here working on his tractor with two unidentified men. In addition to farming, Case served as a Tennessee Valley Authority employee, member of the Civil Air Patrol, and manager of the Muscle Shoals Airport. (Library of Congress.)

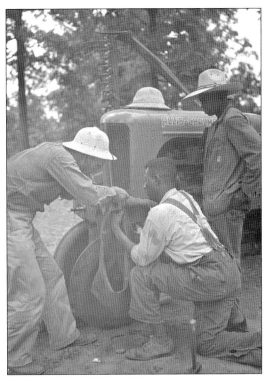

The Locker farm on County Road 47 near St. Florian has been in continuous operation by the Locker family for more than 150 years. Through the years the farm has included row crops, a dairy, and livestock. In 1939, Locker farm workers were photographed by the Tennessee Valley Authority. This image shows the portable engine-powered seed cleaner called "The Clipper." (Library of Congress.)

Livestock like this large Angus bull were vital to agricultural operations in Lauderdale County, including those of Henry D. Louis of Killen. German-born Louis, the white-bearded gentleman who is barely visible on the far right of this February 1920 image, farmed and raised cattle and held a contract with the government to supply meat to workers at Lock Six on the Muscle Shoals Canal. (Courtesy of Ronald Pettus.)

Florence Trading Post, the first trading building in Florence, was constructed in 1938 on Bluff Street between South Court and Seminary Streets, not far from where the current livestock sale barn stands. Owned and operated by Florence's American Legion Post 11, the trading post held weekly livestock auctions for farmers from all over Lauderdale County well into the 1960s. (Courtesy of Steve Cooper.)

Although this Lauderdale County mule might have been photographed on a rural farm, it could just as easily have lived in town. Mules were popular throughout the South for plowing, harvesting crops, and carrying crops to market. They were also used to build roads, railways, telegraph and telephone lines, and even dams and canals. (Courtesy of University of North Alabama Archives.)

The Wesson Sale Barn on Tombigbee Street in Florence sold and traded horses, but it specialized in the sale of war mules in the early 20th century. Mules were called into active duty in both the Civil War and World War I to haul wagons and transport supplies and cargo. John Wesson, shown here standing behind his son Turner Wesson, owned the business. (Courtesy of Steve Cooper.)

Eli Whitney's invention of the cotton gin in 1793 revolutionized the formerly fully manual process of separating cotton fibers from seeds. The South offered ideal conditions for growing cotton crops, and Lauderdale County was among Alabama's most prolific cotton farming communities, so cotton gins like this one in Rogersville were prevalent. (Courtesy of Ronald Pettus.)

Reuben Waddell owned Waddell Cotton Gin, a water-powered gin on Anderson Creek approximately one mile north of the Oliver community in east Lauderdale County. This photograph is said to have been taken during a meeting of the Farmer's Union at the mill in 1907 and includes Bedingfields, Hooies, Chandlers, Cheathams, and Wallaces. Owner Reuben Waddell is seated in the second row from the bottom. (Courtesy of Wayne Higgins.)

Thomas Gibbons, a World War I veteran, owned Tom Gibbons Plumbing in Florence. He often provided plumbing services for Lauderdale County government buildings in addition to his residential clients. Gibbons, pictured here with his sister Viola Petersen at his home on West Tuscaloosa Street, was a member of the Plumbers and Steamfitters Local 760 and American Legion Post 11 until his death in 1971. (Author's collection.)

James Harvey "Jim" McCorkle owned a grocery store in downtown Waterloo. McCorkle was legally blind, but he operated the store on his own. He would walk to the store each day by using a cane and counting his steps and would trust that his customers were providing correct currency. McCorkle's brother Joseph "Joe" McCorkle owned a pharmacy down the street from the grocery. (Courtesy of Diane Romine Hartley.)

In 1937, Tennessee Valley Authority photographers visited downtown Rogersville to capture images of what the Works Progress Administration described as a "farm village" with a 1930s population of 445. Shown here is Rogersville Motor Company, which was located on the north side of Lee Street near present-day Citizens Bank and Trust. (Courtesy of National Archives.)

Hurn Brothers General Store was established in Rogersville in the 1890s, which is most likely when this image was taken. This wooden store was replaced in 1923 with a larger two-story brick structure, and it carried sewing machines, cabinets, stoves, and rugs in addition to groceries. One of the brothers, E.F. Hurn, opened a store in his own name in Rogersville in 1897. (Courtesy of Rogersville Public Library.)

Another view of downtown Rogersville in 1937 shows side-by-side barbershops, Guttery's Barber Shop and Steelman's Barber Shop. Steelman's was likely owned by Roscoe Steelman, who later lived in Limestone County. Barbershops in the 1930s were more than just a place for a shave and a haircut; they were often gathering places for townspeople to share the latest news. (Courtesy of National Archives.)

The very first Rogersville Post Office was established on October 4, 1825, with Thomas Cunningham as postmaster. At the time, the town was known as Rodgersville, but the post office dropped the "d" in the early 1900s. In this photograph, Olis Olin "Jack" Goode and his daughter Reba (Goode) Warren man the post office in the 1940s. (Courtesy of Rogersville Public Library.)

This Lexington store was most likely owned by Andrew Lee Phillips, who was quite well known throughout Lauderdale County. He established his general merchandise store in 1888 and went on to own a gristmill, gin, and flour rolling mill. In 1917, Phillips formed his community's first bank. His brother Thomas J. Phillips operated a large general merchandise store in east Florence. (Courtesy of University of North Alabama Archives.)

Stewart, Foster & Company, agents of Florence Wagon Works, were in business in Lexington from 1910 to 1925. One of the owners, L.M. Foster, became vice president of the Bank of Lexington. He owned a general merchandise store next to the bank and a modern service station and tire store in the early 1930s. (Courtesy of University of North Alabama Archives.)

This building is thought to be W.M. Liles's general merchandise and grocery store in Killen, with the steeple of the old Killen Baptist Church in the background. In 1933, the church was destroyed by fire, and parts of Liles's store, including goods, a chicken house, and a coal bin, were damaged. (Courtesy of University of North Alabama Archives.)

This c. 1930s store is believed to have been Woodland Grocery. The community of Woodland, which was known at various times as Havannah, Savage's Spring, and Reserve, was about nine miles west of Florence and 20 miles east of Waterloo and was inundated with the backwaters of Pickwick Lake in 1938. (Courtesy of University of North Alabama Archives.)

In 1916, Robert "R.E." Angel announced the opening of his new general store in east Florence. Prior to this, Angel was employed as a grocer at the People's Store on Court Street. He died in July 1917 at age 61, leaving behind a wife and five daughters. (Courtesy of Lee Freeman.)

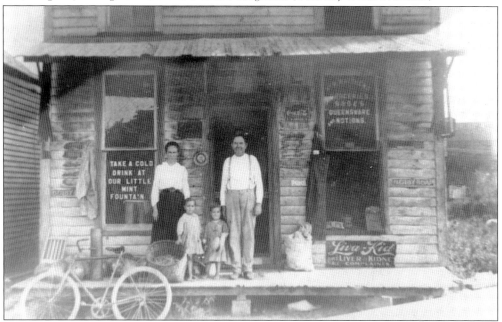

W.M. Matthews, a native of Lexington, was a professor at State Normal College (now the University of North Alabama) before opening this grocery store in east Florence in 1906. His store was known for its mint fountain, which mixed carbonated water with Coca-Cola and fruit juices. In the early 1920s, Matthews moved to a larger two-story brick building at the corner of Huntsville Road and Minniehaha Street. (Courtesy of University of North Alabama Archives.)

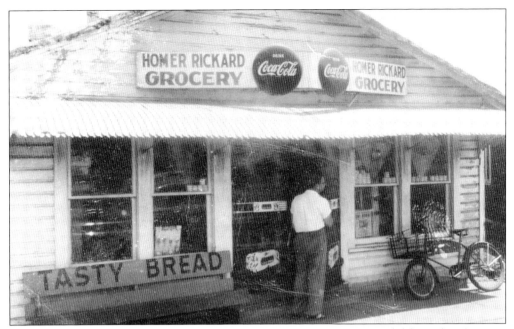

World War I veteran Homer Rickard began his grocery career as a clerk and delivery boy for W.H. Matthews Grocery before opening his own store in the 1930s. In his book *Sweetwater Yesteryears*, historian Bill McDonald wrote that Rickard was an air raid warden for east Florence during World War II, mustering volunteers to make sure lights were out during raids. (Courtesy of University of North Alabama Archives.)

Frank Rickard's Café was one of several eating establishments in the Sweetwater area in east Florence. Rickard's was located on Sweetwater Avenue near the Cherry Cotton Mill. It was a popular place for photographs like this one, where several young men, including Web Tucker (fourth from the left) and Obie Tucker (fourth from the right), pose near a Coca-Cola sign. (Courtesy of University of North Alabama Archives.)

Officials broke ground on the second location of Eliza Coffee Memorial (ECM) Hospital on South Marengo Street in 1942 and opened the doors to patients in September 1943. The four-story white concrete building boasted 75 beds and replaced the previous ECM Hospital, an apartment hotel on East Tuscaloosa Street that was converted to a hospital in 1919. (Courtesy of Wayne Higgins.)

Although the Florence Armory was built by the Works Progress Administration in 1936 primarily to house the local Alabama National Guard detachment, it was also the site of community dances, ball games, and even wrestling matches. Built of stone quarried from Cypress Creek, the armory stood atop the hill facing Florence Cemetery on East Tennessee Street. (Courtesy of Robert Whitten, architect.)

James and Harriet (Adair) Kiddy owned the Kiddy Hotel, which first stood on Aetna Street and was moved to the East Hill in the Sweetwater area of east Florence near Blair, Connor, and Cole Streets. It is said that traveling businessmen would stay here just to enjoy Harriet Kiddy's cooking, delivered from the cellar kitchen to the guestrooms by a hand-operated dumbwaiter. (Courtesy of University of North Alabama Archives.)

Melody Court offered cottages, cabins, boat docks, and a café featuring a "special fish dinner" in the late 1940s and early 1950s. Located in the current location of Marina Mar on Shoal Creek, the facilities were renovated and relaunched as Silver Shores Marina in 1961, offering covered boat slip rentals and "peaceful relaxation." (Courtesy of Robert Whitten, architect.)

A variety of infectious diseases invaded the South following the Civil War. Following a smallpox outbreak in 1865, the City of Florence erected a pestilence house, or pest house, near Wildwood Park where contagious patients could be isolated from the community. In 1878, when 42 Lauderdale County residents died from yellow fever, the pest house was again put into use, and four nurses from a New Orleans charity were sent to tend to the patients. Another smallpox scare sent several citizens to the pest house in 1900. Many of those who died in the pest house were buried in an adjoining cemetery. The structure at Wildwood is thought to have been a simple two-room structure, but another pest house, shown here in March 1908, took the form of a houseboat that could be anchored in waterways throughout Lauderdale County. (Courtesy of Ronald Pettus.)

Five

FELLOWSHIP IN FAITH

Settlers of Lauderdale County often practiced their respective religions in homes or creek side until formal houses of worship were available. Evidence of Catholic visitors has been unearthed alongside Native American artifacts, although the first Catholic church in Lauderdale County was not built until 1872 at St. Florian. St. Joseph Catholic Church in Florence was established in the 1890s and upgraded to this building in 1902. (Courtesy of Lee Freeman.)

Outdoor baptisms like these were quite common across many religions in Lauderdale County and throughout the South well into the 20th century. Although details are unavailable for the image above, the postcard below depicts Church of Christ minister Theophilus Brown Larimore performing a baptism at his home in Mars Hill. Larimore's home stood on the grounds of the current Mars Hill Church of Christ and Mars Hill Bible School campus until it was destroyed by fire in 2018. Cox Creek, once known as Coxe's Creek, runs through the property. Larimore is credited with the remarkable growth of the Church of Christ faith in Lauderdale County. He established a training college for young ministers at Mars Hill in 1871 but closed it in 1887 to preach full-time. (Both, courtesy of Robert Whitten, architect.)

BRO. LARIMORE BAPTIZING AT HIS HOME, MARS HILL, ALA.

Members of the Baptist faith also baptized in natural bodies of water, as did several other faiths. Said to have taken place in the Sweetwater area of east Florence, the African American baptism above may have occurred in one of two "baptizing holes" on Sweetwater Creek; one was located near Cherry Cotton Mill, while the other was close to the earliest location of Freewill Baptist Church at Sweetwater Avenue and Branch Street. The 1930s baptism below included members of Evergreen Baptist Church on Gunwaleford Road and may have taken place in a nearby creek or even in the nearby Tennessee River. Revivals at Evergreen sometimes culminated in baptisms like these. In 1931, a nine-day revival at Evergreen Baptist came to a close with 11 people being baptized and received into the church. (Both, courtesy of University of North Alabama Archives.)

Church picnics are a long-standing tradition in Lauderdale County, providing members of all ages the opportunity to enjoy fresh air, food, fun, and fellowship. They often took place near a creek, such as the gathering above of the members of St. James Methodist Episcopal Church (now St. James United Methodist Church) at Cypress Creek on July 15, 1922. Several of the ladies are wearing bathing caps, indicating they may have taken a dip in the creek. St. James was established in 1895 near the Cherry Cotton Mill in east Florence, later moving to its current location on Cox Creek Parkway. According to historian William "Bill" McDonald, the name *St. James* was suggested by Emma Cherry, whose family owned the cotton mill. She said that the book of St. James was her favorite book of the Bible. (Courtesy of University of North Alabama Archives.)

The congregation of Central Baptist Church, also of east Florence, met for its summer picnic in the early 1920s near the home of Tellie and John Myrick on Sweetwater Avenue, close to Sweetwater Creek. The picture below shows a traditional "dinner on the ground" event, with food spread on yards of sheets and tablecloths. In February 1923, the congregants of Central Baptist celebrated their first service in a newly constructed building on the corner of Aetna Street and Huntsville Road, where the church still stands today. Later that year, when reporting that 21 members of the church had been baptized, the *Florence Herald* called the congregation "an ever-increasing force for righteousness in the community." (Courtesy of University of North Alabama Archives.)

Members of the German Catholic settlement at St. Florian built the first St. Michael's Catholic Church in 1872 across the road from where the church now stands. The original 50-by-24-foot structure was expanded twice, and in 1914, these parishioners gathered in front of their church to celebrate the upcoming construction of the current brick building. (Courtesy of St. Florian History Committee.)

In the Catholic church, altar servers are children or teens who assist the priest during Mass. Here, Fr. Albert Hilger, OSB, of St. Michael's Catholic Church stands with several of the church's altar boys. Father Albert served as St. Michael's priest in the 1930s and 1940s. (Courtesy of St. Florian History Committee.)

The sacrament of First Communion is one of the most important and celebrated events in a Catholic's life and usually takes place at age seven or eight. Annie Kasmeier, Mary Ultsch, and Mary Beumer received the sacrament at St. Michael's Catholic Church in St. Florian from Fr. Leo Mayer, OSB, around 1910. (Courtesy of St. Florian History Committee.)

The Holy Name Society, a Catholic organization, promotes reverence to the holy name of God and helps members grow in holiness. The Junior Holy Name Society is the children's version of the group. Here, members of the Junior Holy Name Society at St. Michael's Catholic Church in St. Florian stand with Father Alphonse in the early 20th century. (Courtesy of St. Florian History Committee.)

The Mallard Creek Primitive Baptist Association, a fellowship of Primitive Baptist churches in Alabama, held its first annual meeting in 1873 and still meets today. In 1934, the association met at Mount Moriah Primitive Baptist Church, which was established in 1896 as Fairgrounds Church and later moved to Irvine Avenue in west Florence. (Courtesy of Lee Freeman.)

The First Baptist Church of Florence was organized in May 1888 with seven members. The first church building, constructed in 1890, was destroyed by fire in July 1909. The congregation broke ground on their second church building, pictured here in this undated image, just four months later. The structure is now used as a chapel as a larger worship center was built in 1963 on the corner of Tombigbee Street and Wood Avenue. (Courtesy of Pope's Tavern.)

In 1904, the Freewill Baptist Church of east Florence erected a new building on Sweetwater Avenue above Cherry Cotton Mill. The church later moved farther up Sweetwater Avenue and in 1964 relocated to its current location on Florence Boulevard. This image of congregation members with Santa Claus was taken at the first location in the 1930s. (Courtesy of University of North Alabama Archives.)

In 1958, members of Killen United Methodist Church ceremoniously broke ground on their new location on J.C. Mauldin Highway. The highway's namesake, J.C. Mauldin, stands third from the left in this image, while Molly Stutts wields the shovel. The building was completed in 1959, and the former church property would later become home to Brooks Elementary School. (Courtesy of Ronald Pettus.)

Six

LEARNING IN
LAUDERDALE COUNTY

Although history did not record the first school established in Lauderdale County, it is thought that the first log schoolhouse was built about 1816 near the Central Heights community with Alexander Faires, a local Methodist preacher, as its teacher. Early schools were often associated with churches. The children seen here in a field in St. Florian were most likely students at St. Florian School. (Courtesy of St. Florian History Committee.)

Although academics have always been the priority in Lauderdale County schools, extracurricular activities are a welcome distraction. In November 1948, students at Elgin School enjoyed the Mr. and Miss Elgin School pageant. Among those pictured here are Ann Walton, Buster McCullough, Ann Butler, Harold Mashburn, Judy Belue, Tommy McCullough, Edna Foust, and Lennis "Junior" Walton Jr. (Courtesy of Rogersville Public Library.)

During the First and Second World Wars, the American Red Cross provided patterns for volunteers to knit items for servicemen overseas. By the end of World War II, volunteers knitted almost 19 million garments for the military. The campaign continued after the war and engaged Americans of all ages, including these fourth graders at St. Florian School, who knit afghans for the Red Cross in 1951. (Courtesy of St. Florian History Committee.)

The Lauderdale Maroons, Lauderdale County High School's 1936 football team, may have had a 2-6 record, but they certainly had the support of their community—as they do today. The newspaper recognized Keifer Belew, Horace Baggett, Capt. Edward Goode, Nile Goode, James Allen Fulks, Loyd Littrell, and Douglas Ezell as outstanding players. (Courtesy of Rogersville Public Library.)

In 1936, Lauderdale County High School (LCHS) had four clubs: the Philomathean literary society, the Riley debate society, Future Farmers of America, and home economics. The Philomathean club, shown here on the steps of the school's second building, was first established at LCHS in 1926 and in 1936 had 29 members. (Courtesy of Amy Ezell Burzese.)

Anderson School--1928-1929
Teachers: Mr. J.A. Nunley, Mrs. J.A
___ Ruby Daly, Robbie Bayles

Anderson Al., Teachers 1933-1934
1st row: Lincoln Hall, Ruby Daly
Robbie Bailes, Myrtle W. Embry,
2nd row: Pearl Romine, Roy Harr[]
Lucille, Tomlinson, Edgar Young,
Annabell Parker, Susie Hamilton.

In 1925, residents of the Anderson community constructed a new school building (seen in the 1928 image above), imposed a tax on themselves to fund the nine-month term, and raised money by private subscriptions of $750 to $1,000 per year to support the education of students at Anderson School. Between 1924 and 1928, enrollment at the school increased by 60 percent, and students excelled in county exams, flourishing under the leadership of Principal J.A. Nunley, who joined the school in 1924. By the 1933–1934 academic year, the school had expanded to nine teachers (pictured at left with Principal Roy Harrison) and 310 students. For 80 of its 100 years, the school served as a junior high school. The Lauderdale County Board of Education closed the school in 2013. (Both, courtesy of Rogersville Public Library.)

Brown's Chapel Church and School were named for Sterling C. Brown, a lifelong Methodist. In 1901, Brown donated a small plot of land for a church at Lingerlost Road and Highway 72. The school, which operated from 1902 to 1916, was built on an adjacent half acre, which was acquired from Brown for $1. Pictured above is teacher Callie Farris with her class in April 1904. Farris taught in several schools throughout Lauderdale County during her career. In 1940, her 40 students at Brown's Chapel School ranged from primary through upper grades. Other teachers at Brown's Chapel included Roberta Joyce, Dr. J.O. Belew, Mollie Stutts, Maggie (Crow) Harrison, Felix Warren, Clayton Calhoun, and Eleanor Daniels. A Mr. Jackson was the teacher of the Brown's Chapel class below. (Both, courtesy of Ronald Pettus.)

Rogersville was selected as the site of Lauderdale County High School (LCHS) after Alabama legislators provided for at least one high school in every county in 1907. The community raised funds to build the two-story facility above. As the first high school in Lauderdale County outside the city of Florence, LCHS attracted students from all over. Some found lodging with Rogersville families for $18–$20 per month during the school year because there were no buses and most families did not own cars. The school burned in 1926, but the community again responded, donating more than half the cost needed to build the modern one-story brick school seen in the 1933 graduation image below. In the late 1950s, that building was also destroyed by fire and was replaced by the current high school structure. (Both, courtesy of Rogersville Public Library.)

The annual banquets held by the Lauderdale County High School Alumni Association were often used as an opportunity for class reunions, like those for the classes of 1916 (above) and 1953 (below), which took place in 1963. The association was founded in 1913, the same year the school held its first graduation of three students, Irene Davis, Tonice Belue, and John W. Howard. The group enjoyed healthy participation from its beginnings; in fact, 400 alumni were expected at the 1928 banquet, and more than 100 members from 20 LCHS graduating classes attended a meeting in 1933. (Both, courtesy of Rogersville Public Library.)

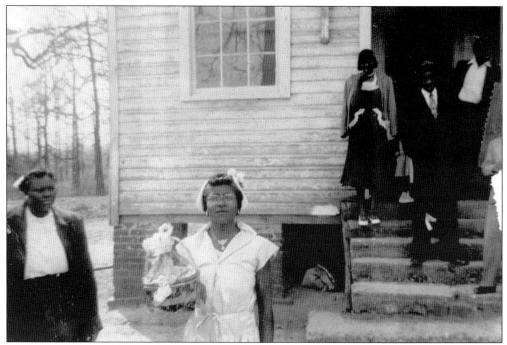

Hewitt School near Bailey Springs educated first through sixth grade African American students from the 1920s to the 1960s. Nicknamed the "Hustle School," Hewitt was built for $1,000 as part of the Rosenwald School Building Program, which funded small schools for Blacks in rural Alabama. Pictured here on Easter Sunday 1950 are members of the Brannon and Brown families. (Courtesy of Lee Freeman.)

John F. Slater School served Black elementary students beginning in 1900, when the school's total enrollment was 130. The school, whose last class is shown here, was located on South Court Street and was improved and enlarged several times as it grew. The city merged Slater with Burrell High School in the 1950s and built a new facility on College Street for the 1960–1961 school year. (Courtesy of Lee Freeman.)

St. Florian School was founded just after the parish received its first permanent priest, Fr. Michael August Merz, in 1873. Father Merz's niece Annie Merz was the school's first teacher. Classes were held in the original wooden St. Michael's church building until a small school was constructed across the road from the church. A brick building replaced this one in 1926, and an auditorium-gymnasium was added in 1949. These buildings still stand across from the church. In 1968, St. Michael's School combined with St. Joseph School in Florence. St. Joseph Regional School serves the parishes of St. Joseph, St. Michael's, and Our Lady of the Shoals in Tuscumbia. (Both, courtesy of St. Florian History Committee.)

The Lutts community lies just across the Tennessee state line near Cloverdale and was home to Dodd's School. Herbert Koonce, seen here with his students at Dodd's, was a native and lifelong resident of Lauderdale County. After teaching for several years, Koonce served as probate clerk, engaged in the lumber/contractor business, operated a large county farm, and served as president of the Lauderdale Farm Bureau. (Courtesy of Lee Freeman.)

Like his brother Herbert, Elmer Koonce was a teacher as well as a general contractor. Elmer Koonce, pictured here with his class at Pisgah School around 1905, also taught at Willow Bluff School in the Threet community. He was later elected to the Lauderdale County Board of Education. (Courtesy of Lee Freeman.)

Underwood School was built between 1895 and 1900 on farmland owned by William Underwood, who relocated here after Union forces burned his employer's mill in Florence. The school later moved to its current location on Cloverdale Road in Petersville on land donated by the Phillips family. The image above is the class of 1910 with teacher Dora Blakeley on their last day of school at a "dinner on the ground," while the image below shows the class of 1915. (Both, courtesy of University of North Alabama Archives.)

Center Star School is believed to have been founded in the mid- to late 1800s and existed well into the 20th century. At one time, the school stood on Huntsville Road, also known as Lee Highway. This image of the fifth and sixth grades at Center Star School in 1935 indicates that the school was small, but it was certainly beloved by the Center Star community. (Courtesy of Ronald Pettus.)

Rocky Knoll School was a one-room schoolhouse in the Woodland community between Oakland and Waterloo. In 1897, the school had 63 students. This image from about 1907 includes all students in first through 12th grades. Among the teachers at Rocky Knoll were D.O. Warren, Alice McKelvey, John Wood, and Nanny Quigley. (Courtesy of University of North Alabama Archives.)

The first Killen School, a stark one-room structure on Jones Avenue, opened in 1908 and offered a seven-month schedule. Parents had to buy the desks, and teachers used curtains to separate classes as the school grew. In 1935, the school was moved to a new brick building and for the first time had a nine-month academic schedule. Newer facilities followed in the 1960s and 1985. In 1969, the name of Killen School was changed to Brooks Elementary. Principal Johnny Cochran, shown above with the class of 1929, was a World War I veteran who later became CEO of Woodmen of the World. (Both, courtesy of Ronald Pettus.)

Rhodesville school was located 15 miles west of Florence off Waterloo Road. Like many rural schools, Rhodesville often held ice-cream socials and box suppers to raise funds during the first three decades of the 20th century. This 1932 fourth-grade class, with a Mr. Parker as its teacher, included late Lauderdale County historian Orlan Irons. (University of North Alabama Archives.)

Although there was most likely a school in Waterloo when it was settled in 1819, the first record of a school building is found in 1872. By 1895, Waterloo supported a seven-month school and three teachers. Students from neighboring counties, Mississippi, and Tennessee often boarded with Waterloo families before buses and cars were common. This image from 1917 likely includes many boarders. (Courtesy of University of North Alabama Archives.)

Cloverdale School was founded on July 8, 1897, and served the community of Cloverdale until 2012. In its early years, school classes were conducted in a white frame building that was remembered for its potbellied stove, outdoor toilets, and water students would transport from an outdoor well. By 1957, when this photograph was taken of the first-grade class, Cloverdale was housed in a brick building. (Courtesy of Steve Cooper.)

Jackson School was located on County Road 154, just north of Wesley Chapel United Methodist Church on County Road 15. It is believed this image of Jackson School students and their teacher, Mary Ethel (Koonce) Cooper, was taken in the 1900s or 1910s. Other teachers included Grace Spain, Roy T. Blackburn, D.G. White, Fannie Young, and Lilah White. (Courtesy of Steve Cooper.)

Liberty Baptist Church and Liberty School, also known as Threets School, at Threets Crossroads, for several years shared the white building in the background of the undated school photograph above. One hundred fifteen pupils were enrolled in 1925, and by 1927, a total of 155 students participated in boys' and girls' basketball teams, clubs, and theater. Early teachers included Venus Broadfoot, Ida Harrison, Dewey White, Bertha Weatherwax, Beulah Smith, and Odell Mitchell. The photograph below from 1958 shows Vera Kelley and her students from Threets's fourth, fifth, and sixth grades. When the school closed in 1968, its teachers were transferred to Central School. (Above, courtesy of Florence-Lauderdale Public Library; below, courtesy of Steve Cooper.)

Central School opened for students in October 1928 with five teachers. The school's founders were John Henry Haddock, Sam Haddock, Roy T. Blackburn, Dora Murphy, and Elmer Koonce, who each contributed $1,000 to funds donated by the community. Koonce was in charge of construction of the brick building, which for 52 years served students from Burcham Valley, Lovelace, Threets, Woodland, Oakland, Smithsonia, Cloverdale, and Rhodesville. The images here of the 1949–1950 sixth-grade (above) and eighth-grade (below) classes show portions of that original building. In 1978, the school was dismantled and replaced with separate elementary and high schools, which still exist today. (Both, courtesy of Charles E. Alexander.)

Wilson School was established in 1916 by members of the Hines community, including Henry Cathey, a businessman who later served as postmaster of Florence. The school was named after the Wilson brothers, who lived in the area. The school moved to its current site on Chisholm Road in 1920; this image from 1920 most likely shows the new facility. In the early 1920s, Esther Barfield established several girls clubs at local schools; in 1923, a total of 24 Wilson girls enthusiastically enrolled to learn how to dye fabric, card wool, and other home improvement skills. By 1924, the school had established a basketball team with the Yellow Jackets as its team name, and in 1925, there were 119 students enrolled at Wilson. The school's first kitchen and lunchroom were built in 1940 using discarded lumber from closed schools. Early teachers included Walter Parker, Eula Reid, Roy Taylor, and Lizzie Taylor. It was not until the late 1960s that Wilson School added a high school program, with the first class graduating in 1970. (Courtesy of Florence-Lauderdale Public Library.)

Seven

HAPPY IS THE HOME

Lauderdale County is dotted with historic properties, including plantations, notable homes, and commercial sites. This Tennessee Valley Historical Society map shows several of these locations. Although many of the original structures are no longer standing, some of the properties they occupied hold vestiges of their former glory. (Courtesy of Robert Whitten, architect.)

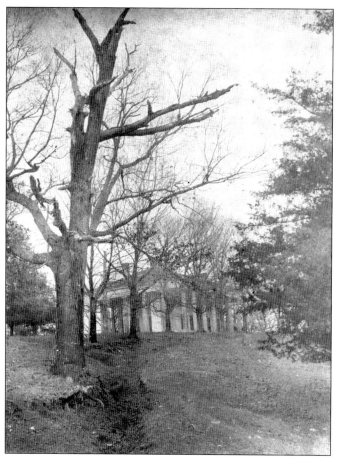

The Forks of Cypress plantation, home of Irish immigrant James Jackson Sr., was completed in 1830 and originally encompassed 3,000 acres just west of Florence. The plantation's name was taken from the two forks of Cypress Creek (Big Cypress and Little Cypress), which converge near the homesite. As a member of Cypress Land Company, Jackson became one of the founders of Florence. The Forks property included stables, blacksmith and carpentry shops, a large garden, and a regulation racetrack for Jackson's prized horses. James Jackson died in 1840 and was buried in the adjacent family cemetery, which is still maintained. The house burned on June 6, 1966, after being struck by lightning; however, the 24 distinctive columns that surrounded the house on all four sides remain. (Both, courtesy of Ronald Pettus.)

In 1860, James Jackson's widow, Sally, owned 80 slaves who lived in 14 slave houses like these. Over 250 Jackson slaves, including *Roots* author Alex Haley's great-grandmother Easter, are buried in a cemetery on the property. The Forks plantation served as the setting for Haley's book *Queen: The Story of an American Family*. Enslaved people built plows and wagons in the onsite carpentry and blacksmith shops, cultivated cotton and corn, and produced molasses and butter. In 1993, Heritage Preservation Inc. performed an archaeological study of one of the saddlebag log cabins on the property. Like the cabin in the undated photograph below, it was distinguished by two rooms separated by a wall with a central chimney between them. (Above, courtesy of Pope's Tavern; below, courtesy of University of North Alabama Archives.)

Ardoyne, located five miles west of Florence on Gunwaleford Road, was one of the early plantations on Gunwaleford Road. It was built by the Hannas, a Lauderdale County pioneer family. It was later purchased by Andrew Jackson Hutchings, nephew of Pres. Andrew Jackson's wife, Rachel, and ward of War of 1812 general John Coffee. Lastly, Ardoyne was home to Alexander Donelson "A.D." Coffee, an innovative farmer, mill owner, Civil War captain, and John Coffee's son, who died there in 1901. The image at left shows the foyer of the home before it burned in November 1919. Coffee's memory lived on, though, as Coffee High School was named for him, and Eliza Coffee Memorial Hospital was named for his daughter with second wife, Camilla (Madding Jones) Coffee. (Above, courtesy of Wayne Higgins; left, courtesy of University of North Alabama Archives.)

The Smithsonia community, about 13 miles west of Florence, is named for Columbus Smith, who arrived in Lauderdale County after the Civil War. Smith built a financial empire as a merchant, ginner, and tradesman. In 1883, Smith replaced his original 1871 homestead with this cut-stone mansion. At his death in 1900, he had accumulated an estate that included Koger Island and 10,000 acres of land. (Courtesy of Pope's Tavern.)

This home, formerly located on Gunwaleford Road near Savannah Highway, is thought to have been owned by Henry Dawson Smith. Henry D. Smith Sr. served in the Alabama House of Representatives for 12 years, and his son Henry D. Smith Jr. practiced law in Florence. (Courtesy of University of North Alabama Archives.)

This classic dogtrot-style cabin, said to be located at the McKiernan plantation on Chisholm Road in Florence, featured a breezeway between two separate cabins. Typically, one cabin was used for cooking and dining while the other offered living and sleeping space. The breezeway served to cool each cabin. (Courtesy of University of North Alabama Archives.)

Adam Weaver built this log house on Highway 72 just west of Rogersville in 1838. Adam Weaver died in 1865, but the home remained in possession of the Weaver family until at least 1929. When the house was photographed in 1935 for the Historic American Buildings Survey, it was said to be in a state of disintegration. (Library of Congress.)

The Taylor-Cunningham homes were situated on Bellview Road between the Bellview and Center Star communities. Pioneer Benjamin Taylor built the dogtrot-style log cabin shown above soon after settling in Lauderdale County, replacing it in 1858 with the more substantial two-story home shown below. It is said that during the Civil War, Benjamin's daughter Susie Poke Taylor refused to play the piano for the Union soldiers camped on the land. After the war, Susie married Capt. Jonathan McDavid Cunningham Jr. and inherited her father's plantation. Members of the Taylor-Cunningham family, including Sgt. Maj. J. Weakley Cunningham of the 57th Alabama Infantry, occupied the land for over 100 years. These images were taken in 1935 as part of the Historic American Buildings Survey; today, neither structure is still standing. (Both, Library of Congress.)

The home of Henry Chappell Warren stood on Church Street in Rogersville. Warren was born in Giles County, Tennessee, but spent most of his life in Rogersville. He retired as a rural mail carrier in 1948 and served as mayor of Rogersville from 1953 to 1955. He died in this home in 1957. (Courtesy of Amy Ezell Burzese.)

Eight

Then Came the People

The lore of Lauderdale County would be nothing without the people who have called the county and its close-knit communities home, like these five young women. Pictured from left to right, Martha Nell Ezell, Ellen (Crymes) Whitehead, Bessie Ruth (Crymes) Rowden, Dimple (Whitehead) Romine, and Mary Lois (Ezell) Graham seem to be enjoying themselves while at the same time pointing folks in the direction of the town of Rogersville. (Courtesy of Amy Ezell Burzese.)

Joseph Milton "Joe" and Mary Ethel (Koonce) Cooper, grandparents of local historian Steve Cooper, were married in 1913 and lived in the Cloverdale community. Mary Ethel was a teacher at Jackson School, and before his marriage to Mary Ethel, Joe was a schoolteacher at Pine Hill School. Joe served as a mail carrier, retiring from that position in 1954, and was also a merchant at Cloverdale. In this image, Joe is carrying his mailbag. Mary Ethel died in 1931 at age 40, and Joe died in 1955. (Courtesy of Steve Cooper.)

Jabez Pugh Cannon was a private in Company C, 27th Alabama Infantry Regiment. He lived in the Gravelly Springs community with his parents, Jabez and Sarah (Reeder) Cannon before the Civil War, during which he kept a diary that was published afterwards. Cannon became a physician and practiced medicine in McKenzie, Tennessee. (Courtesy of Tennessee State Library and Archives.)

Edward Asbury O'Neal, Alabama's 26th governor, was born in 1818. When he moved to Florence in the 1840s to practice law, he saw this home being built on North Court Street (then Market Street) and vowed to buy it for his wife; he did so in 1857. Here, O'Neal (in the long coat near the center of the photograph) stands in front of his home with family members shortly before his death in 1890. (Courtesy of University of North Alabama Archives.)

Mary Douglass Bender, seen here with two unidentified gentlemen and a mule, graduated from Florence State Teachers College in 1935 and became a teacher at both Patton and Brandon elementary schools. She was a longtime member of First United Methodist Church in downtown Florence, where she taught the Character Builders Sunday school class for so long that it was renamed in her honor. (Courtesy of University of North Alabama Archives.)

Mary Hoernig was one of 16 children of Frank and Maria Hoernig, who immigrated to Wisconsin from Germany with Mary and four of her siblings in 1889. The family moved to the German Catholic St. Florian community in 1909. Mary married Henry G. Stumpe, and after his death, she married Frank Peters. Mary is fondly remembered as an active member of St. Michael's Catholic Church. (Courtesy of St. Florian History Committee.)

John Ashley and Sarah E. "Sally" (Halbert) Bedingfield were married in Lawrence County but settled in the Rogersville community. They lived on Huntsville Road, which like Highway 72 today connected Florence to Huntsville. Their youngest son, Johnie Halbert Bedingfield, is shown here at about age seven. (Courtesy of Rogersville Public Library.)

JOHN H. BEDINGFIELD
SALLY E. BEDINGFIELD (wife)
HOLBERT BEDINGFIELD (youngest son)
about 1908 or 1910

Zachariah "Uncle Zack" and Lucinda (Perkinson) Romine were lifelong Rogersville residents. Zack's father, Peter, served in the War of 1812, and his mother, Sarah, lived to be 98. Zack was known as the "poet laureate" of Rogersville due to his frequent contributions to the local newspapers. He was a Mason and justice of the peace and died at his home in 1910 at age 80. (Courtesy of Lee Freeman.)

This property on Savannah Highway, known as Cypress Hill, was home to the Thomas S. Broadfoot family. Pictured from left to right are Nan Duncan, Cleo Duncan, Thomas S. Broadfoot, infant Hugh Barton Duncan, Betty J. Broadfoot Duncan, and Lillian Reed. The home was later purchased by Bill and Milly Wright, who owned the nearby Flying Carpet store. (Courtesy of University of North Alabama Archives.)

Civil War captain David Howell, shown here with his wife, Sarah, served as superintendent of the Lauderdale County poor farm on Chisholm Road from 1896 to 1903. During his tenure, Howell treated the residents with respect, labored to improve the facilities and land, and often exhibited vegetables grown on the farm at the county fair. (Courtesy of Lee Freeman.)

The home of Felix and Mahala (Lovelace) Wood on Cloverdale Road near the Cloverdale community is another example of a dogtrot-style cabin. The couple was married in 1875, and by 1910, when this photograph was taken, had nine children, six of whom were still living. Felix worked as a farmer for most of his life and died in the 1940s. (Courtesy of Lee Freeman.)

William J. and Martha Josephine "Josie" (Campbell) Freeman, who married in 1888, lived and farmed in the Cloverdale community. The couple's four sons, including Allen (left) and Earl, who are seen here with their mother in 1917, pitched in to maintain the property after their father died in 1910. (Courtesy of Lee Freeman.)

Frank and Nannie (Campbell) Livingston, seen in this undated photograph, married in 1893 and settled in the Cloverdale community. Nannie was one of several Gold Star mothers in Lauderdale County, having lost her son David in World War I. In 1930, she traveled to France to visit the US Army cemetery where he was buried. (Courtesy of Lee Freeman.)

Rosanna Gist was born in Lauderdale County in 1854 and married Miles Ingram in 1869. Together, they had 13 children, 11 of whom were still living in 1900. The Ingram home was located on Lexington-Pulaski Road. Rosanna was widowed in the 1890s and died in 1937. (Courtesy of Lee Freeman.)

Rev. Harrison Ingram was a popular Presbyterian minister in the Rogersville community of Lauderdale County. He worked as a stonemason and owned a limestone quarry across from the current location of Joe Wheeler State Park. In 1881, Harrison and his father established Ingram-Thornton Cemetery in Rogersville. The cemetery is now known as the Thorntontown Cemetery, and Harrison, who died in 1937, is buried there. (Courtesy of University of North Alabama Archives.)

Reuben "Uncle Rube" Patterson accompanied Col. Josiah Patterson of the 5th Alabama Cavalry, Confederate States of America (CSA), throughout the Civil War. At one point, he was captured by Union forces and placed in charge of a colonel's horse. He reportedly went missing from his assignment, appearing a few days later at Colonel Patterson's headquarters with the Union colonel's horse and saddle. After the war, Patterson served as a cook at the Muscle Shoals Canal for 25 years. When men from Lauderdale County left for Cuba in 1898 to join the Spanish-American War, he emotionally expressed his desire to join them in the fight. In 1924, he traveled from Florence to Memphis, Tennessee, for a Confederate veterans' reunion, proudly wearing his CSA uniform. He was photographed with Mary Gardner Patterson, Colonel Patterson's granddaughter. Reuben Patterson died in 1928 at age 95. Members of the United Daughters of the Confederacy and Sons of Confederate Veterans attended his funeral, as they held him in high esteem, and Malcom Patterson, the 30th governor of Tennessee, sent flowers. (Courtesy of Tennessee State Library and Archives.)

Kit Butler was born into slavery in 1852 in Marengo County, Alabama, and as a child moved with slave owner Martin Butler to a plantation in Clarke County, Mississippi. After settling in Center Star in 1872, he often recounted to townsfolk his memories of hearing the cannons of Civil War battles and watching Union soldiers marching by. He also remembered the moment a man came to the plantation to announce that slaves had been freed. Martin Butler immediately released him, but Kit stayed on to work for him until 1866, when he moved to Birmingham. When he moved to Lauderdale County in 1868, he crossed the Tennessee River by ferry because the bridge had been burned by Confederate soldiers to deter advancing Union soldiers. Butler died in 1961 near Center Star, where he had lived on Lee Highway with his friend Major Fields. He was just a few months shy of his 110th birthday. (Courtesy of University of North Alabama Archives.)

The home of Henry and Nora White Mitchell was behind the current location of the Rogersville Library. Henry was a Lauderdale County merchant and farmer. This photograph from 1913 includes Henry and Nora, eight of their children (Clara, Flossie, Streetie, Esters, Villard, Naomi, Millinea, and Hautie), and a friend. (Courtesy of Joysan Wilson Collier.)

"Uncle" Tom Wilson served as the postmaster of Wright, also known as Wright's Crossroads, which sits at the intersection of County Road 8 and Waterloo Road. The post office at Wright was established in 1891 and was discontinued in 1911. At one time, the community was known for its production of lumber, specifically crossties, which were transported abroad from the Wright's Landing boat launch. (Courtesy of Wayne Higgins.)

Franklin C. Peck, right, and John Samuel Peck, pictured with his family below, were two of six children of Frederick and Renetta Lassman, who immigrated to America in 1854 from Mocker, Germany, and settled in the Center Star community. Frederick and Renetta had 42 grandchildren and, accordingly, have many descendants in Lauderdale County. Lured by agricultural opportunities, Franklin and his family moved to Oklahoma in 1916; however, several of his children returned to Lauderdale County. John Samuel Peck bought a farm just east of his father's on County Road 428 and there raised his large family of 13 children—3 with first wife, Mary, and 10 with second wife, Oma Tidwell. (Both, author's collection.)

Mary Martina Danley married James Warren Gray in 1871, and together they had 10 children. After James's death in 1889, Mary wed Walter F. Stutts and had a son. This image shows Mary with nine of her children. Mary, a midwife, is wearing a watch on her belt that she used when delivering babies. The Danley, Stutts, and Gray families were all early Lauderdale County settlers. (Courtesy of Lee Freeman.)

Florence (Threet) Gibbons (right) received a community service award from B'nai B'rith, a Jewish service organization, in December 1954. Also pictured with Gibbons are, from left to right, B'nai B'rith Tri-Cities Lodge member Harold S. May, lodge president Morris Klibanoff, and Willie White from the Veterans Administration hospital in Tuscaloosa. Gibbons was born at Threets Crossroads in Lauderdale County and was well known for her charitable work with veterans. (Author's collection.)

The Threets Crossroads community in north Lauderdale County was originally named Russell's Crossroads but is thought to have been renamed for John Threet, who settled in the area soon after the county was formed. John was married to Sarah Shelby, daughter of Reese Shelby, another early settler. Sarah died in 1840, and John died in 1850, leaving nine children. Will Threet, pictured above with his family, and Rosie Lee (Threet) Lindsey, pictured below with her husband, Wylie Alonzo Lindsey, and their family, were among the many descendants of John and Sarah who also called Lauderdale County home. (Above, courtesy of Florence-Lauderdale Public Library; below, courtesy of Lee Freeman.)

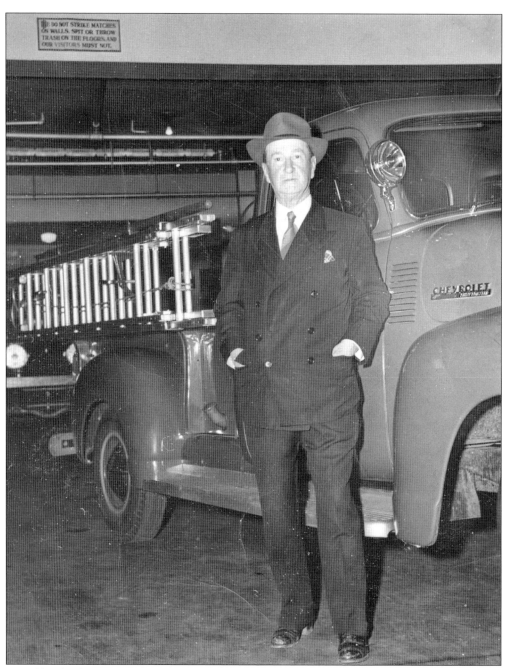

Donald White's 52 years of service with the Florence Fire Department included 40 years as fire chief, from 1913 to 1921 and from 1924 to 1954. He and his wife, Lena (Stoves) White, were active in the community and were members of First United Methodist Church in downtown Florence. White was the son of William T. and Susan (Tidwell) White, also lifelong Lauderdale County residents. Donald White is remembered as a meticulous recordkeeper of Florence Fire Department history and kept a large scrapbook of pictures and newspaper clippings. During his tenure, White is said to have brought about efficiencies, modernizations, and improvements and provided his department with the best equipment available. (Author's collection.)

Upon the founding of Lauderdale County in February 1818, one of the first actions taken by Governor Bibb was to appoint county officials. Joel Rice was appointed sheriff; James Fyles, coroner; and Joseph Farmer, county treasurer. Others were appointed throughout the next year until the new county was fully equipped. In 1893, several Lauderdale officials posed for a photograph in front of the first courthouse, including E.S. Gregory, George W. Porter, H.B. Gresham, and Judge W. B. McClure. A 1900 souvenir edition of the *Florence Herald* offered this description of the county: "Taxes are not burdensome, land is not expensive, labor is plentiful, [and] honest officials are in charge of the county government. . . . With these conditions it would be strange if Lauderdale were not one of the best counties in the state." (Courtesy of Florence-Lauderdale Public Library.)

Discover Thousands of Local History Books
Featuring Millions of Vintage Images

Arcadia Publishing, the leading local history publisher in the United States, is committed to making history accessible and meaningful through publishing books that celebrate and preserve the heritage of America's people and places.

Find more books like this at
www.arcadiapublishing.com

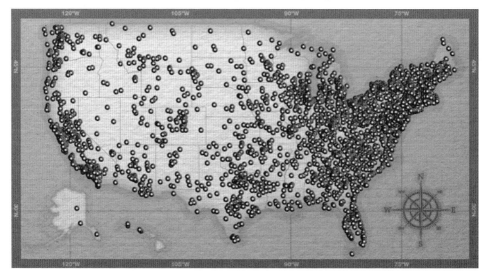

Search for your hometown history, your old stomping grounds, and even your favorite sports team.

Consistent with our mission to preserve history on a local level, this book was printed in South Carolina on American-made paper and manufactured entirely in the United States. Products carrying the accredited Forest Stewardship Council (FSC) label are printed on 100 percent FSC-certified paper.

MADE IN THE USA